Mountain Stream

I wanted to emphasise the gentleness of the rolling hills in the distance in this painting, so I placed a waterfall in the foreground to act as a foil. For variety I added a ploughed field. The foreground water and the sky are soft and calm, which helps to force the eye to the central area of the painting, which is where I want the viewer to look.

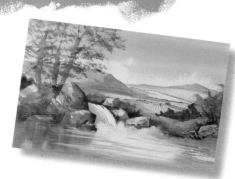

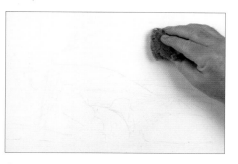

1 Begin by dampening the sky using a damp sponge. Avoid over-wetting the paper.

2 Before it dries, make a thin mix of Winsor blue (green shade) and a tiny amount of cadmium scarlet and paint in the sky, taking the colour down over the tops of the mountains. Use the 25mm (1in) flat brush.

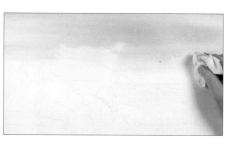

3 Dab out a suggestion of clouds using a crumpled piece of dry kitchen paper.

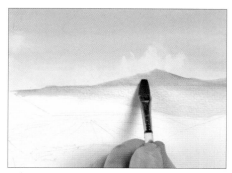

4 Add a little cadmium scarlet to the mix and put in the tops of the distant mountains using the smaller flat brush. Fade the colour out towards the bottom.

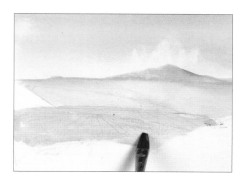

5 Use a little cadmium lemon to put in the hill in the mid-ground. Moving forwards towards the foreground, put in the next hill using new gamboge, and the one in front of that using burnt sienna.

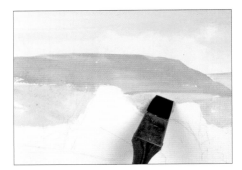

6 For the hill on the left, use more autumnal colours – new gamboge, cadmium scarlet and a little cobalt blue. Apply the paint with the larger flat brush. Paint the area in front of the hill using a mix of Winsor blue (green shade) and a little cadmium lemon.

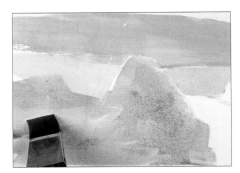

7 Begin to put in the rocks in the foreground. Use new gamboge, a little cadmium orange and some cadmium scarlet, a touch of cobalt blue and some permanent rose. Lay the colours in separately and allow them to mix on the paper.

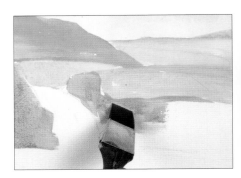

8 For the rocks in the middle of the picture use cadmium orange, new gamboge and some cadmium scarlet.

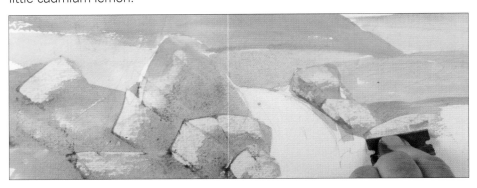

9 Use a razor blade to scrape away the paint where the sunlight catches the rocks. This adds depth and texture. (The light is coming from the left.)

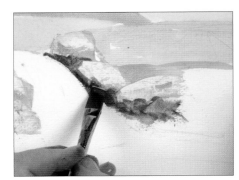

10 Using the small flat brush, put in some dark foliage and strengthen the edge of the waterfall. Use Winsor blue (green shade) and burnt umber.

Tip

When using a razor blade to scrape out highlights, make sure the paint is still wet and place the razor blade with the edge flat on the surface. Tilt the blade in the direction you wish to scrape and firmly push the pigment in that direction.

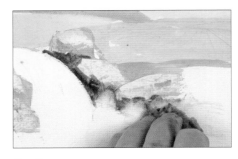

11 Work into the paint firmly with a damp sponge, pushing the pigment to one side. This creates soft patches of white, which will eventually become areas of spray rising from the waterfall.

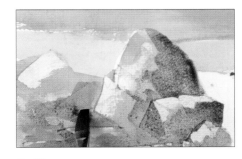

12 Make up a small quantity of shadow mix (touches of permanent rose and cadmium scarlet added to cobalt blue) and put in the shadows on the left-hand rocks.

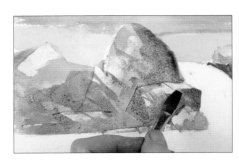

13 Put in the diagonal shadows cast by the trees. Soften the base of the rocks with a damp sponge if necessary.

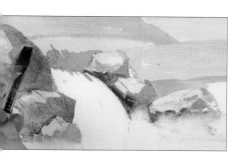

14 Add shadows to the rocks on the right, and use the same mix to put in the suggestion of distant foliage at the top of the waterfall. Introduce more cadmium orange into the foreground rocks on the left.

15 Changing to the large flat brush, paint the area of foreground on the right of the picture. Use a mixture of yellows, blues, reds and oranges. Apply them singly and allow them to blend on the paper.

16 Darken the lower area using burnt sienna and French ultramarine.

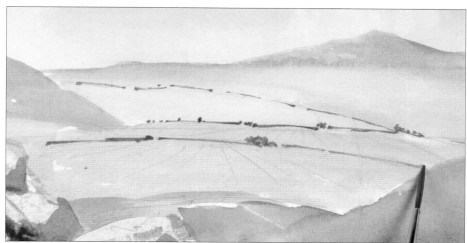

17 Push a damp sponge up into the lower edge of the paint to suggest foam at the base of the waterfall.

18 Using the no. 3 rigger, put in the distant hedgerows as thin, irregular, broken lines with occasional dots of paint for trees and shrubs. For those in the distance use a mix of new gamboge and cobalt blue; for those further forwards add a little more red.

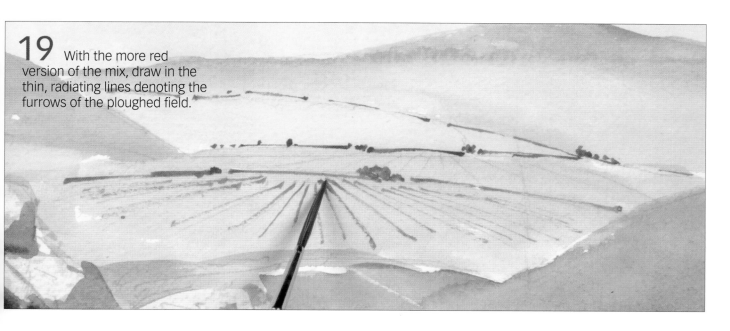

19 With the more red version of the mix, draw in the thin, radiating lines denoting the furrows of the ploughed field.

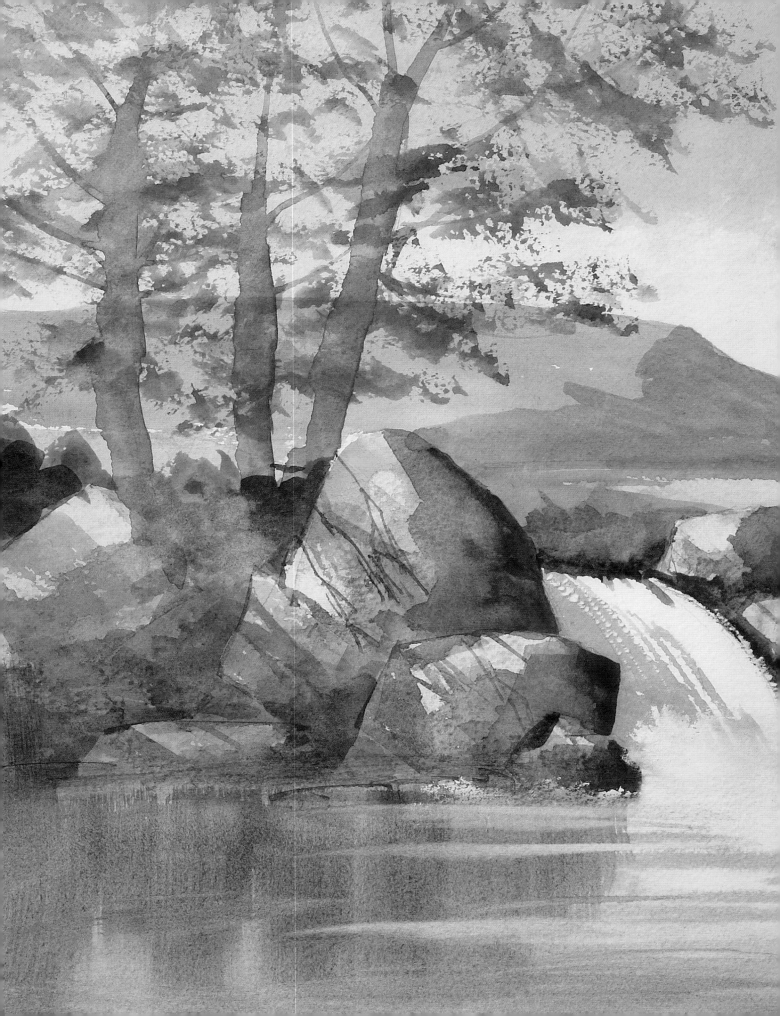

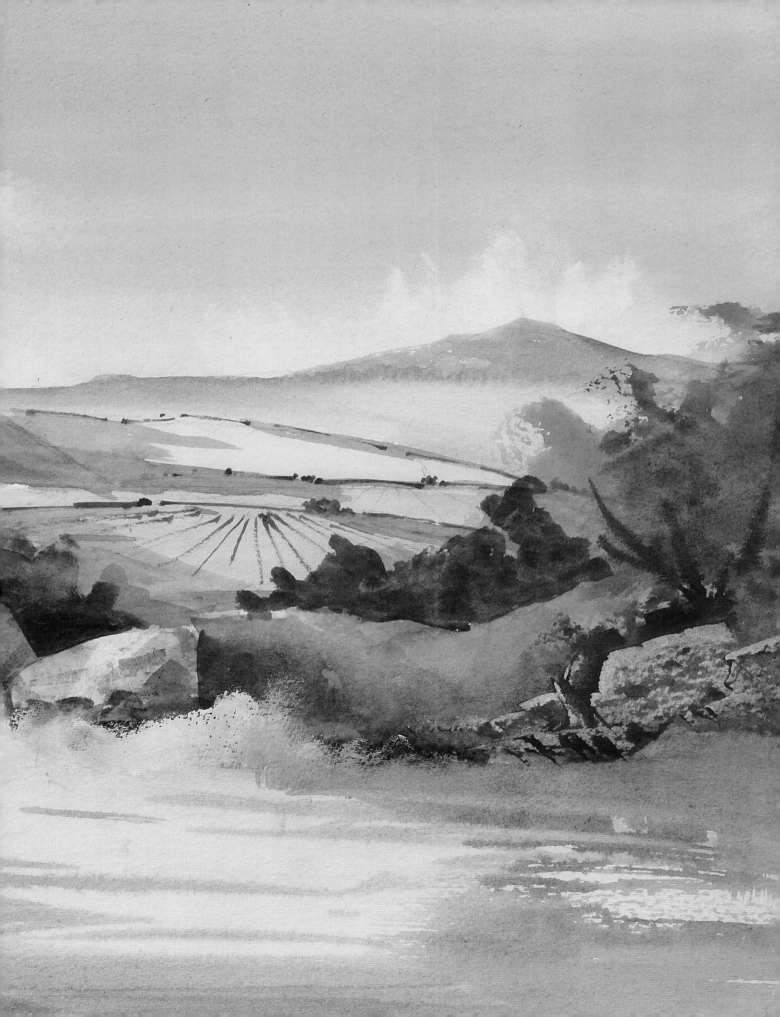

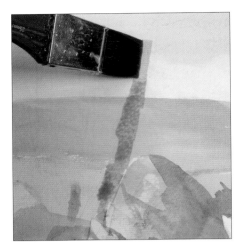

20 Start to place the main trees on the left. Use the larger flat brush and the same green mix as in the previous step. Apply the paint with the flat edge of the brush and using horizontal strokes, pulling the paint from one side of the trunk to the other.

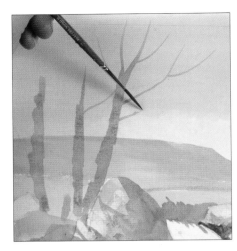

21 Returning to the rigger, put in three trunks, all at slightly different angles, then add a little more blue to the mix and put in the main branches at the tops of the trees. Paint each branch with a single, sweeping stroke from the trunk to its tip.

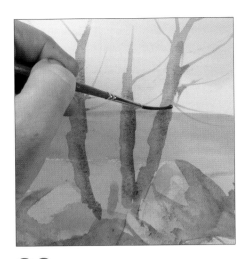

22 Use the shadow mix (see step 12) to lay in the shadows down the right-hand sides of the tree trunks (the light is coming from the left).

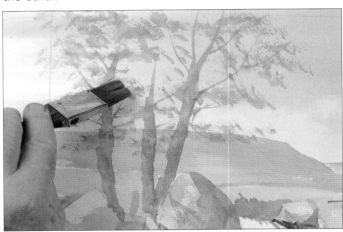

23 For the foliage, make a mix of cobalt blue, cadmium lemon and a touch of cadmium orange. Dab the paint on firmly using the corner of the 25mm (1in) flat brush – this will give your painting a more 'sparkly' finish.

Tip

Dabbing paint on using the side of the brush results in a varied, 'sparkly' finish rather than a flat area of colour.

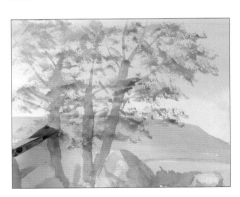

24 Add a little red to the mix for the darker foliage at the bottom and on the right.

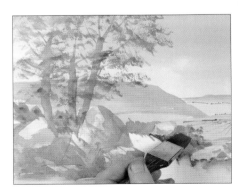

25 Use the darker green to put in some shrubs at the base of trees and on the right-hand side of the waterfall.

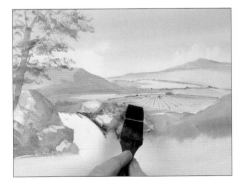

26 With the standard shadow mix (see step 12), use the flat edge of the brush to place the shadows on the right-facing side of the mid-ground mountains and across the fields in the background.

27 Use the corner of the brush to paint on the shadows on the waterfall, in the same direction as the flow of the water.

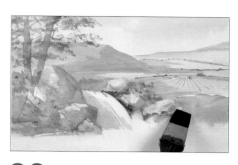

28 Strengthen the shadows on the rocks on the left and on the area of ground on the right.

29 Make a dark mix of burnt sienna and French ultramarine and put in the darks at the base of the ground to the right of the waterfall. Soften the edges with a clean, damp brush.

30 Use a damp sponge to soften the bottom edge here and there, where it meets the edge of the water.

31 Put in the shrubs and bushes on the right using the light green mix used for the foliage in step 23 (cobalt blue, cadmium lemon and a touch of cadmium orange).

32 Strengthen the colour with the darker green, then paint in some branches using the burnt sienna and French ultramarine mix and the no. 3 rigger.

33 Scrape out the rocks below the shrubs using the razor blade, as you did in step 9.

34 Using a very dark green mix of cadmium lemon, French ultramarine and cadmium scarlet, darken the foliage at the base of the large trees on the left. This will make the light areas look lighter. Use the smaller flat brush.

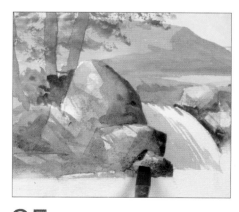

35 Make a cooler version of the mix by adding some cobalt blue and place a strong shadow down the right-hand side of the main rocks. Soften it in with a clean, damp brush.

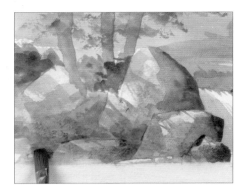

36 Using a slightly weaker version of the same mix, place more shadows on the remainder of the rocks. Soften them in as before.

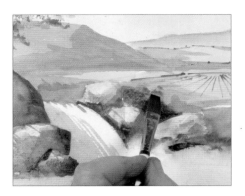

37 Apply shadows to the right-hand rocks in the same way.

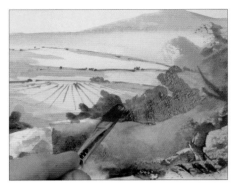

38 Deepen the colour of the shrubs and bushes on the right-hand side of the picture using the same dark green mix as the one you used in step 34.

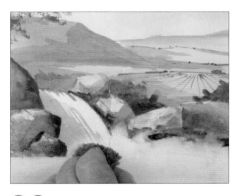

39 Soften the edges of the waterfall using a damp sponge, if these have started to dry.

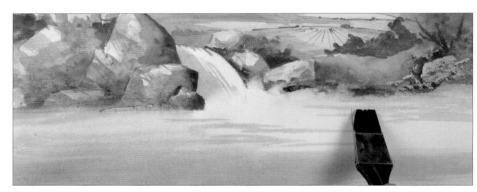

40 Dampen the area of water with a clean, damp sponge, then paint it using a pale mix of cobalt blue. Apply the paint using horizontal strokes of the larger flat brush. Create ripples by moving the edge of the brush horizontally across the wet paint. Ensure there is less water in the brush than on the paper – the water will then be drawn from the paper to the brush. Leave the area in front of the waterfall free of colour.

Tip

To create sparkle on the water, hold the brush flat against the surface and drag it across without pushing the paint into the paper.

41 Using the same variety of colours you used for the rocks, drag the reflections from the base of the rocks into the water. Try to keep the tonal values the same.

42 Do the same on the other side of the picture.